OUR WORLD

OUR WORLD

Photographs by Molly Malone Cook

Text by Mary Oliver

BEACON PRESS

Boston

Beacon Press
25 Beacon Street
Boston, Massachusetts 02108-2892
www.beacon.org

Beacon Press books
are published under the auspices of
the Unitarian Universalist Association of Congregations.

10 09 08 07 8 7 6 5 4 3 2 1

This book is printed on acid-free paper that meets the uncoated paper ANSI/NISO
specifications for permanence as revised in 1992.

Text design by Dede Cummings/DCDESIGN

Library of Congress Cataloging-in-Publication Data
Cook, Molly Malone, 1925–2005.
Our world : photographs by Molly Malone Cook / text by Mary Oliver.
p. cm.
ISBN 978-0-8070-6880-9
1. Photography, Artistic. 2. Portrait photography. 3. Cook, Molly Malone, 1925–2005.
I. Oliver, Mary. II. Title.

TR654.C67155 2007
779.092—DC22 2007013403

OUR WORLD

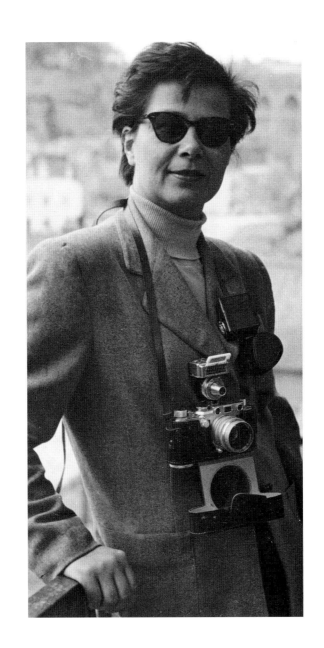

Molly Malone Cook,
Europe, 1950s (photographer
unknown).

NOTE

In previous writings I have referred to
Molly Malone Cook simply as M., and
this is how, with few exceptions, I refer
to her in the following pages.

THOUGH YOU HAVE KNOWN SOMEONE for more than forty years, though you have worked with them and lived with them, you do not know everything. I do not know everything—but a few things, which I will tell. M. had will and wit and probably too much empathy for others; she was quick in speech and she did not suffer fools. When you knew her she was unconditionally kind. But also, as our friend the Bishop Tom Shaw said at her memorial service, you had to be brave to get to know her. Trust was not greatly at her service, but loyalty was.

She kept everything—in the darkness of an uncountable number of boxes, in file cabinets. I have said many a prayer to patience these past months, searching out the negatives—some of them a half century old—of the many photographs that she developed and printed and, by the late sixties, put away. In some cases the work was wonderfully organized, but often it was not. In some cases the photographs or negatives were precisely dated, at other times I have had to make a judgment, knowing, from her journals, pretty much where she was in the years before we met.

All of the photographs in this volume are black and white. There are many color negatives and prints also in the boxes, but that, perhaps, is for another time.

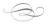

Narrative offers insight. When M. was a small child someone asked her what she wanted to do when she grew up and she answered, "I want to see every face in America."

She was born in 1925 in San Francisco. It was not the most fortunate beginning; years later she searched for and found her parents. But for many years she was moved through various temporary homes—a childhood of mystery and insufficiency. It is not hard to guess the reason she wanted to see faces: to find someone, somewhere, who would be recognizable, would look like her.

Once, in a letter, she wrote:

> My mother was an infant,
> my father was a child,
> so I grew up immensely dour
> and wild…wild…wild.

Dour she could be, but privately. She was Irish, after all, and liked to sing and to have a good time. Occasionally over the years she would phone a friend she had met in Europe; she would put records on the phonograph, the old songs they both knew, and they would sing together, long-distance, and not necessarily briefly.

She loved cars and liked to drive fast. She learned to fly, in a single engine Cessna. One day as we were driving up the highway she called out—"Stop! There's my boat!" No matter she had never driven a boat, no matter that this one came with a 190-horsepower engine. We bought it.

She was impulsive. She could brood deeply and for days; she sometimes entered, almost irresistibly, into intense and difficult relationships. She loved to tease me, and was shocked that I

never got it, not for years. Finally I did—I got a little humor myself—and this pleased her greatly. It took a long time, though, to get there.

She was style, she was an old loneliness that nothing could quite wipe away; she was vastly knowledgeable about people, about books, about the mind's emotions and the heart's. She lived sometimes in a black box of memories and unanswerable questions, and then would come out and frolic—be feisty, and bold.

M. went to Europe as a young woman (long before we met) to see the great European sights, to enjoy the good times of youth. When funds ran out she applied for a job at a personnel office of the U.S. Army in Germany, and was hired to be a personnel officer. It was at this time, I believe, that photography became a serious interest. She traveled to every country there is, or was, taking pictures. This, for me, in my searching for prints and negatives, offered an unexpected and special joy, for here, in pictures taken by friends using her own camera, I saw her; a laughing, dark-haired woman, in Venice, in Paris, skiing in Switzerland, accompanied by friends as well as her ever present, well-traveled dog.

When she returned to the United States she took an apartment in the Village and, with a friend, continued to work in photography. She took classes with Harold Feinstein. She began to know other photographers. She worked for the newly formed newspaper *The Village Voice*—taking pictures. In 1958 and 1959 she traveled by car across the country, to California, leisurely, through the south and back through the northern states—taking pictures. She had, around this time, an

affair that struck deeply; I believe she loved totally and was loved totally. I know about it, and I am glad. I have an idea of why the relationship thrived so and yet failed, too private for discussion—also too obviously a supposition. Such a happening has and deserves its privacy. I only mean to say that this love, and the ensuing emptiness of its ending, changed her. Of such events we are always changed—not necessarily badly, but changed. Who doesn't know this doesn't know much.

(Text continues on page 39)

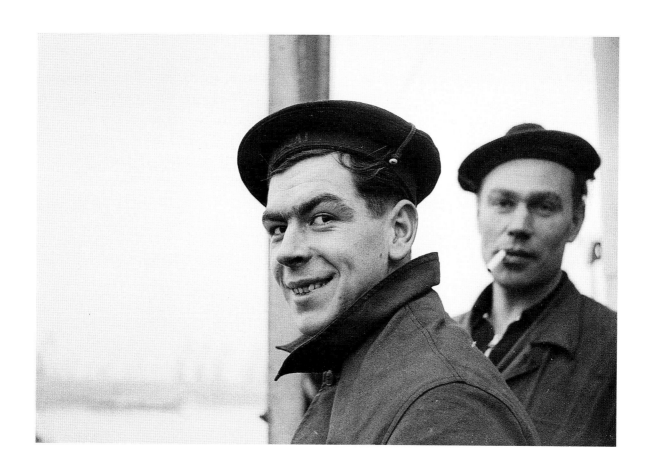

Two sailors, France,
December 1953.

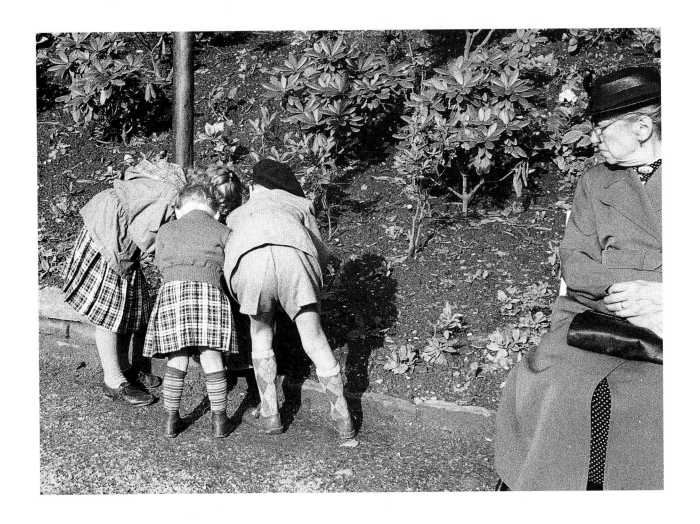

Woman
watching
children,
Heidelberg,
August 1954.

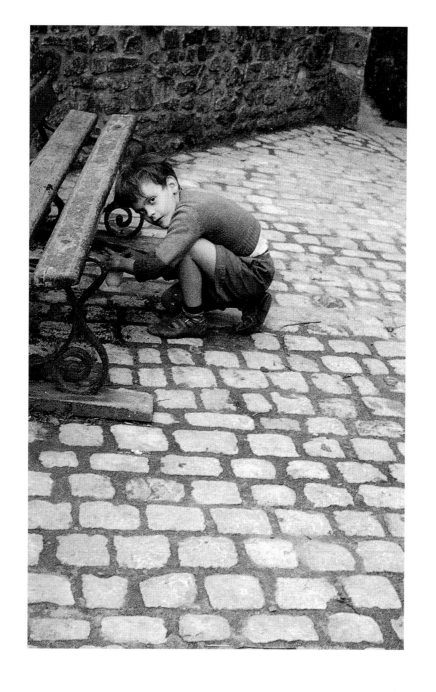

Boy in castle in North Germany, July 1954.

In Francis Steegmuller's biography, *Cocteau*, *there is a photograph of him in Paris in 1947.* *"One of the few unposed photographs of Cocteau" reads the caption.*

So here is another.

The photographer can be seen in the back-wall mirror.

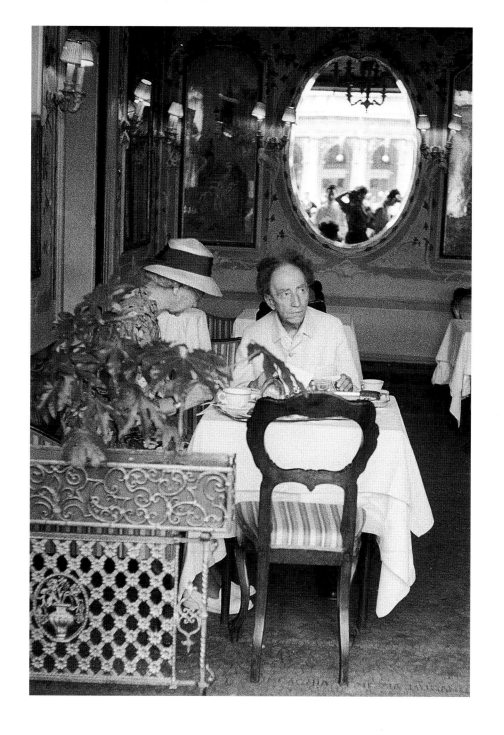

Jean Cocteau and
unidentified
companion,
Venice,
May 30, 1954.

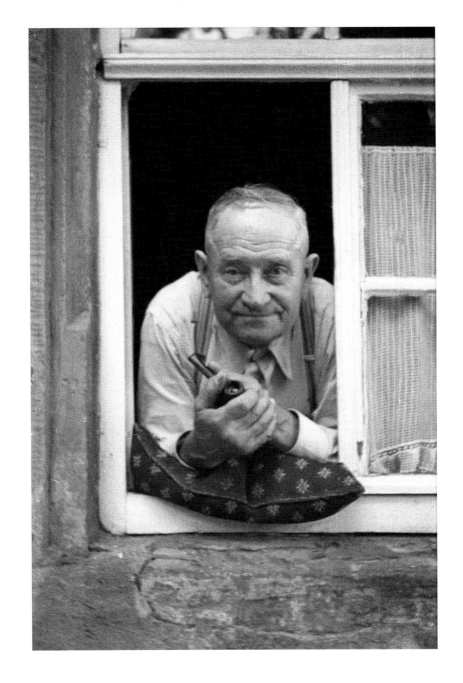

Germany,
the 1950s.

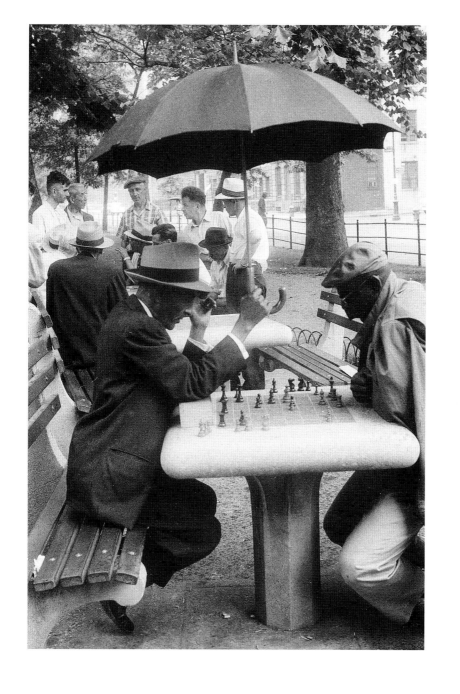

Chess players,
Washington
Square,
New York City,
late 1950s.

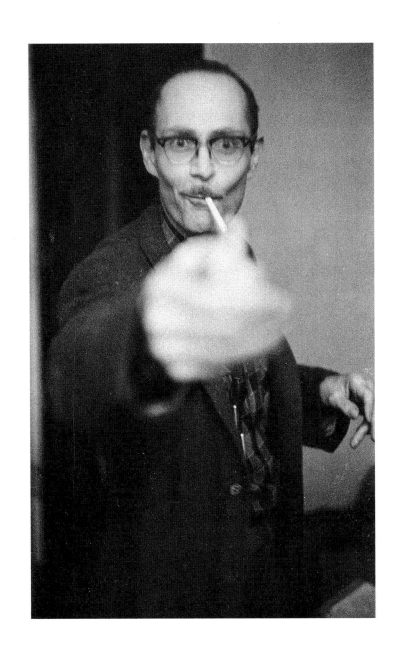

The photographer
W. Eugene Smith,
New York City, 1962.

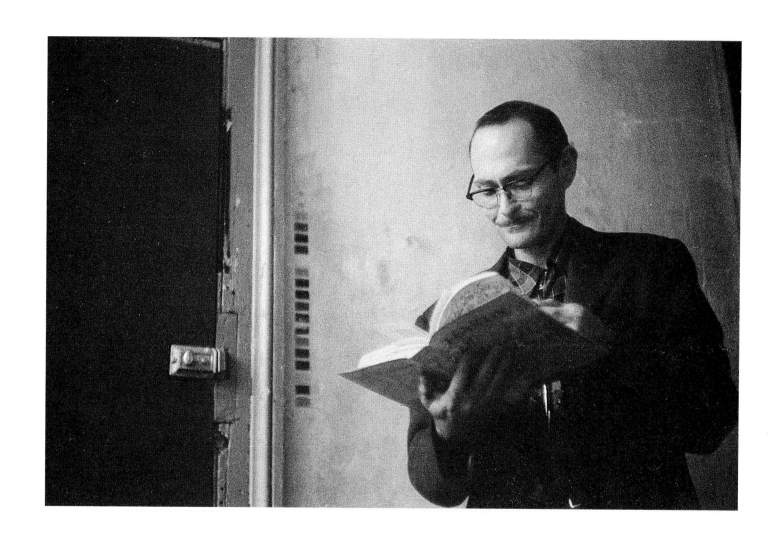

Smiling this time.

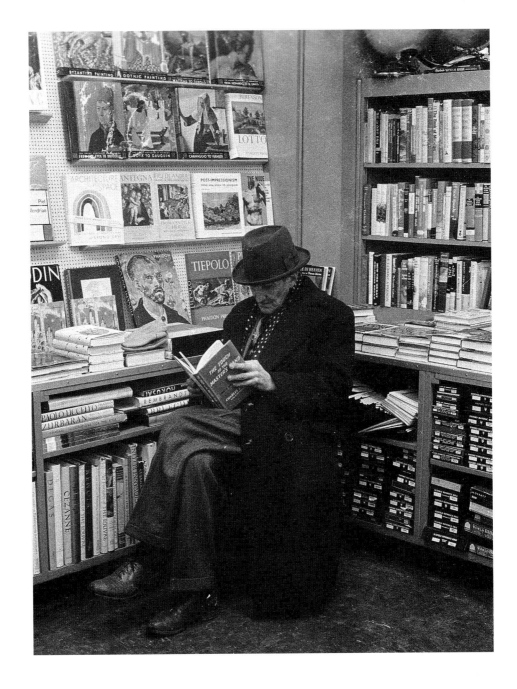

New York City, late 1950s.

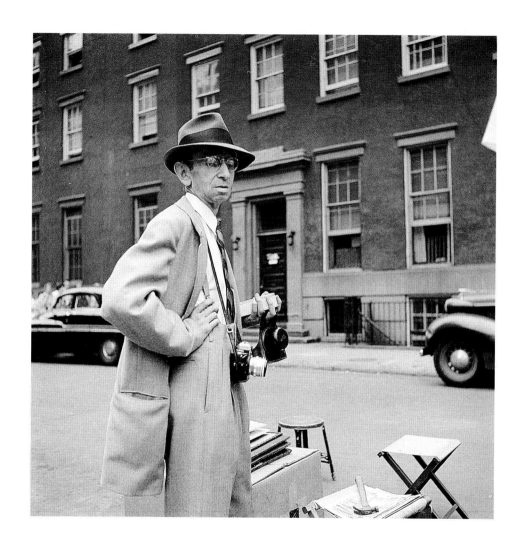

*Street
photographer,
New York City,
late 1950s.*

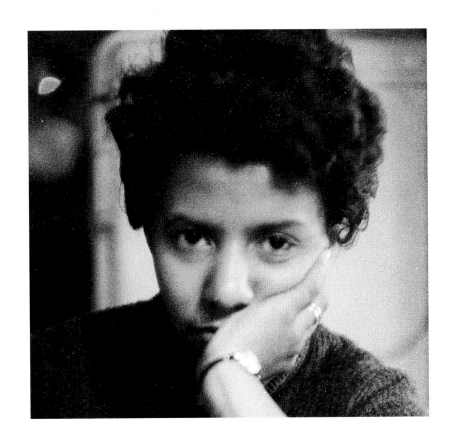

Playwright Lorraine Hansberry,
author of A Raisin in the Sun, *both*
photographs New York, 1957 or 1958.

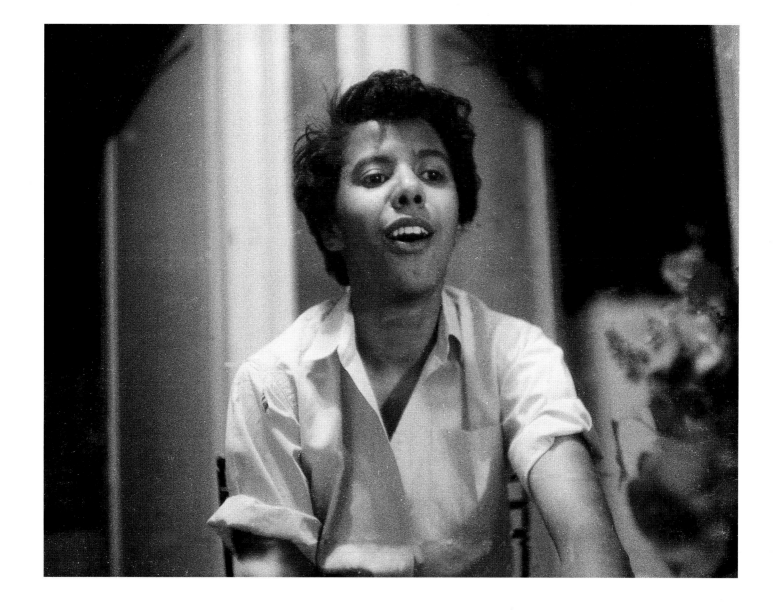

Singing.

When M. went off on her travels across the country she stopped to visit Lorraine Hansberry's uncle, George Perry, in Columbia, Tennessee, bringing him photographs of his niece.
Which he seems to like very much.

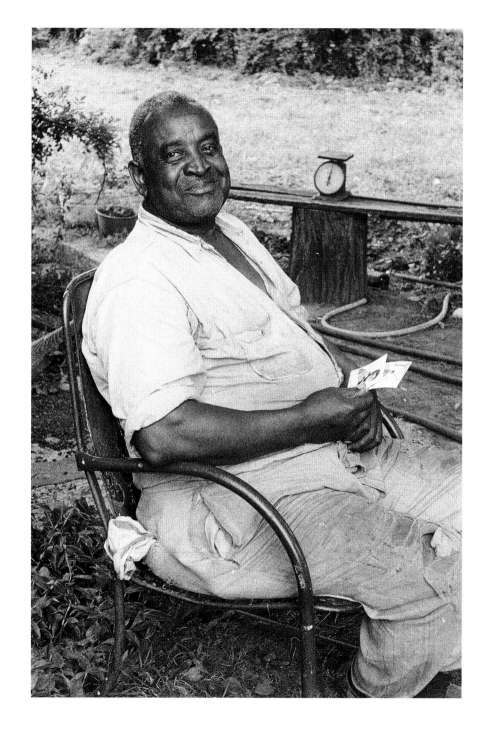

George Perry, 1958.

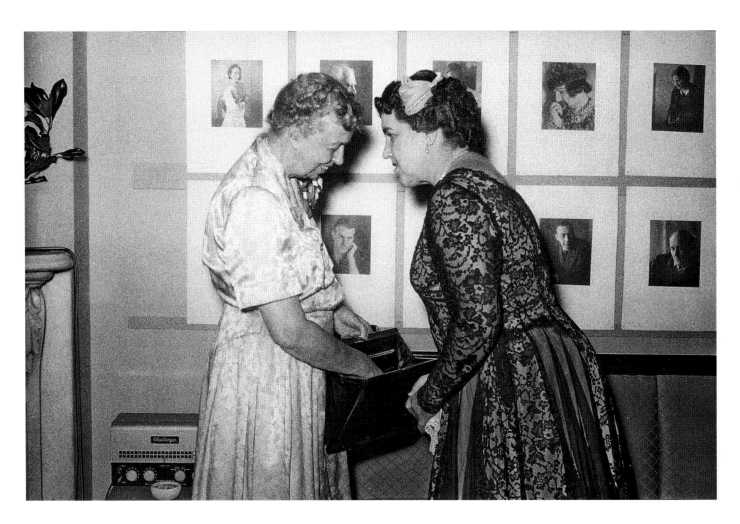

Eleanor Roosevelt at the
Pen & Brush Club in
New York City, October
26, 1956.

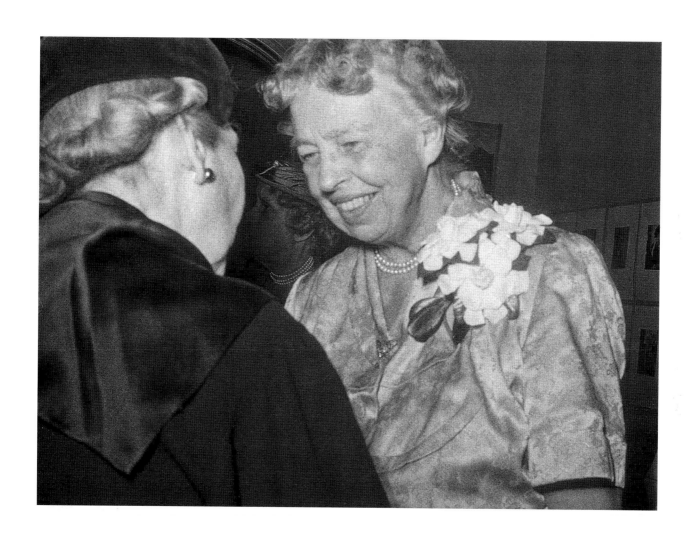

Listening.

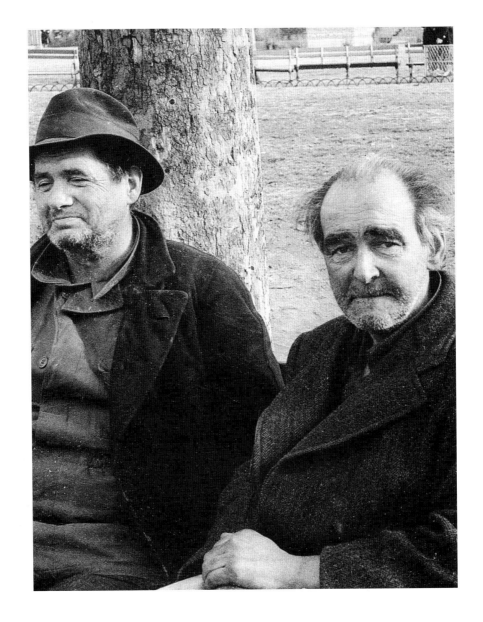

Willie (on the right) and
friend, Greenwich Village, 1950s.

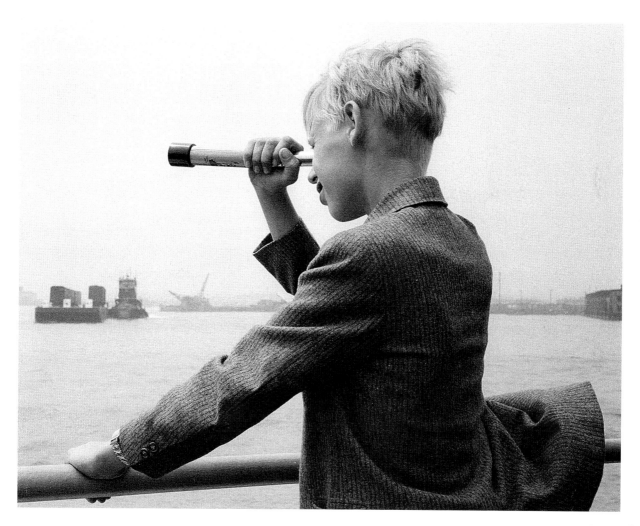

Boy with telescope,
New York Cruises, late 1950s.

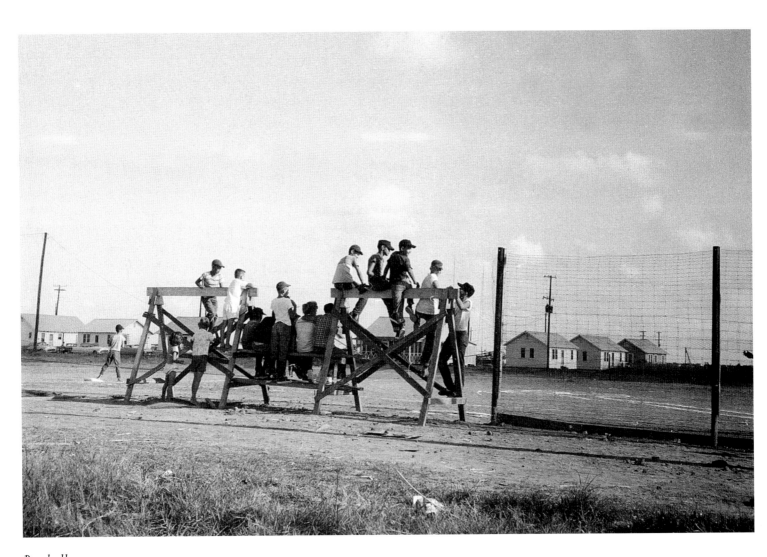

Baseball,
somewhere in the West, 1950s.

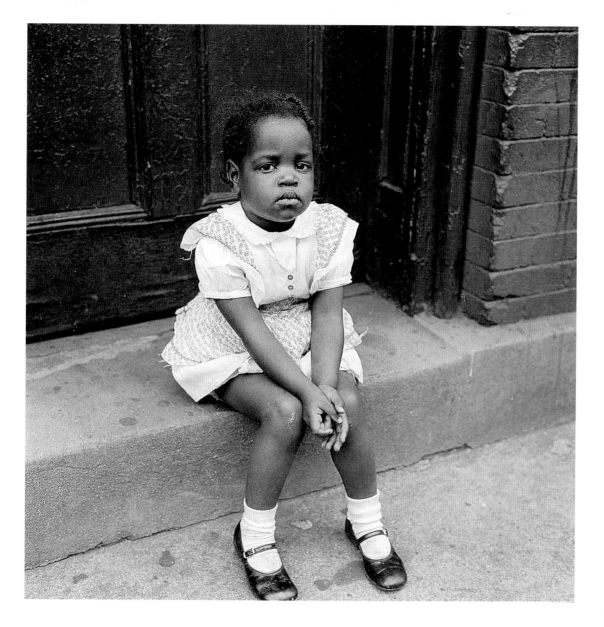

New York City,
1950s.

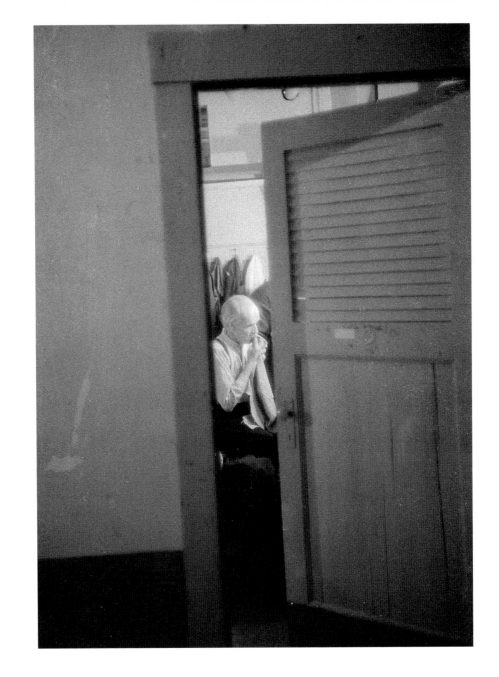

Actor Harrison
Dowd, backstage
before the opening
of The Visit,
New Haven, 1958.

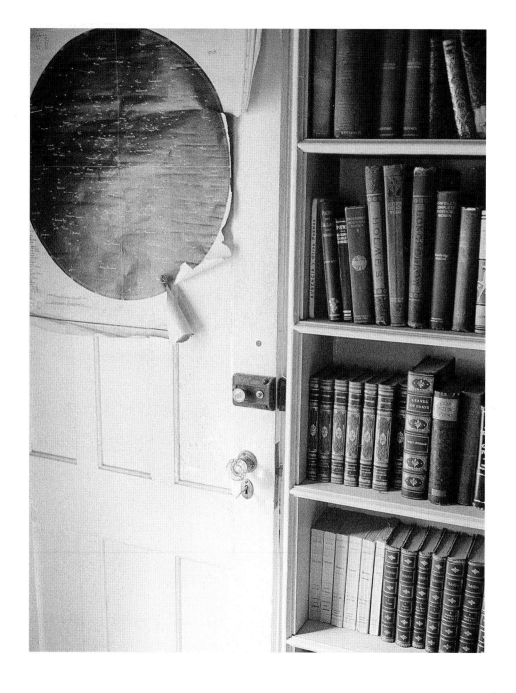

Inside the library at Steepletop, the home of the poet Edna St. Vincent Millay, late 1950s.

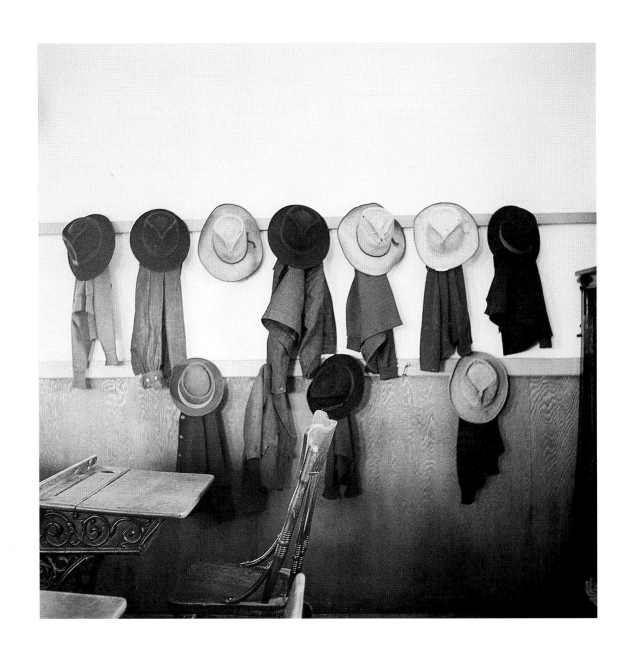

Amish
schoolroom,
1950s.

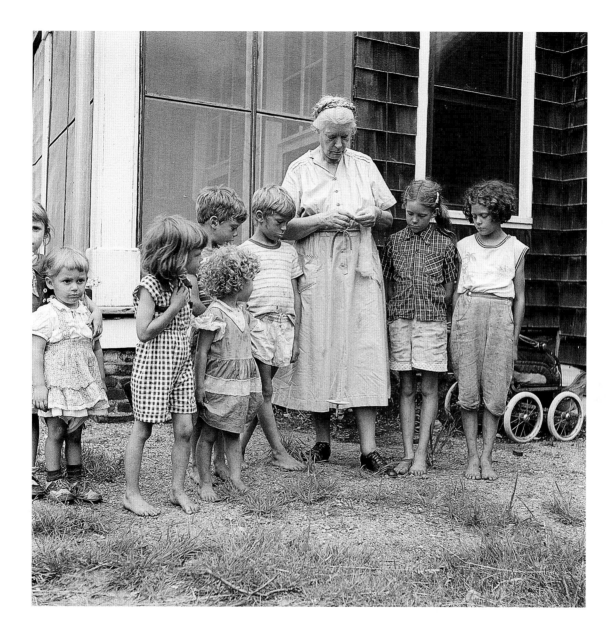

The Catholic activist Dorothy Day and children, 1950s.

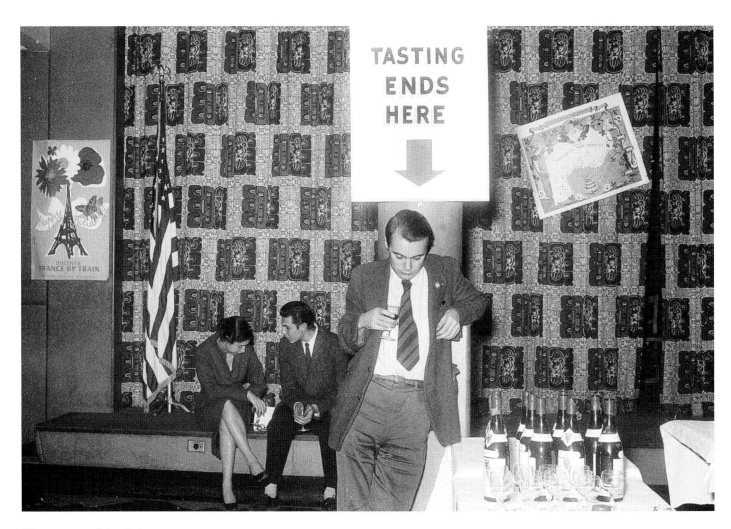

Wine tasting, New York
City, 1950s.

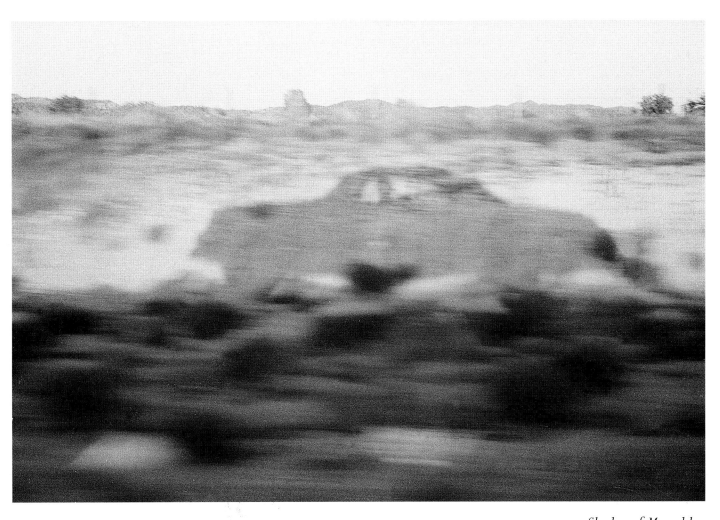

*Shadow of M. and her
convertible against a
sand embankment, 1958.*

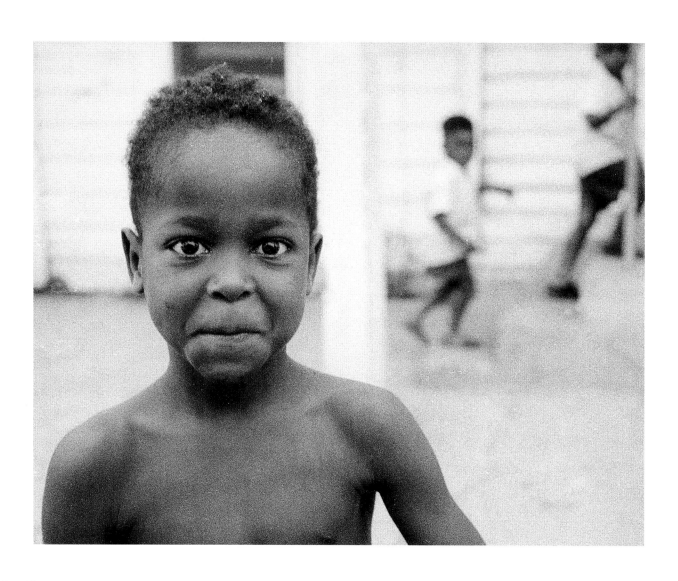

Magnolia, Mississippi, 1958.

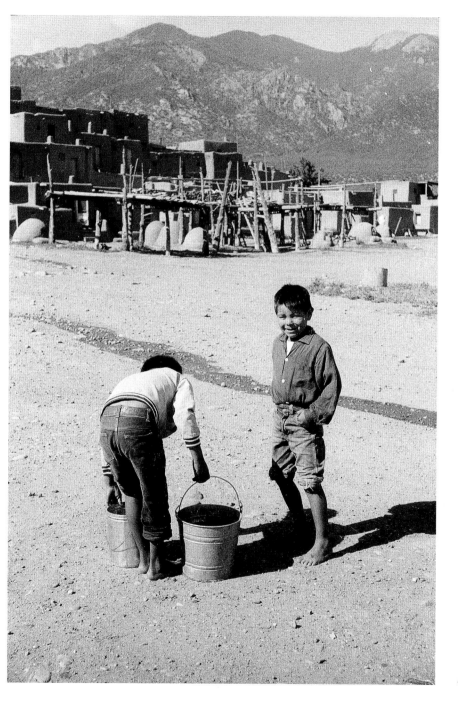

New Mexico,
1958.

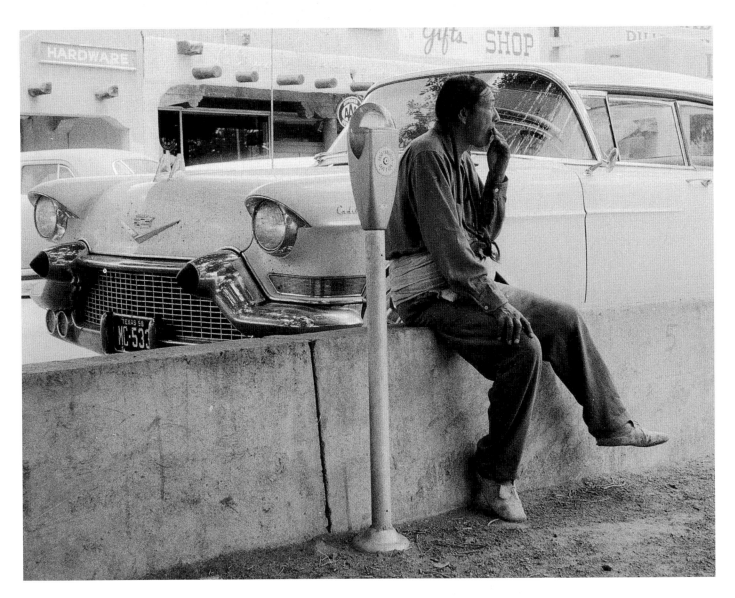

New Mexico, 1958.

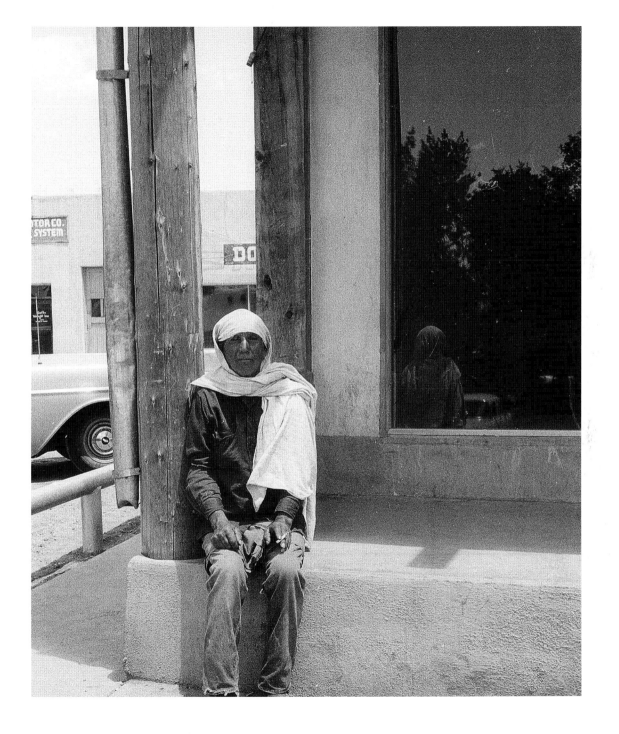

New Mexico,
1958.

35

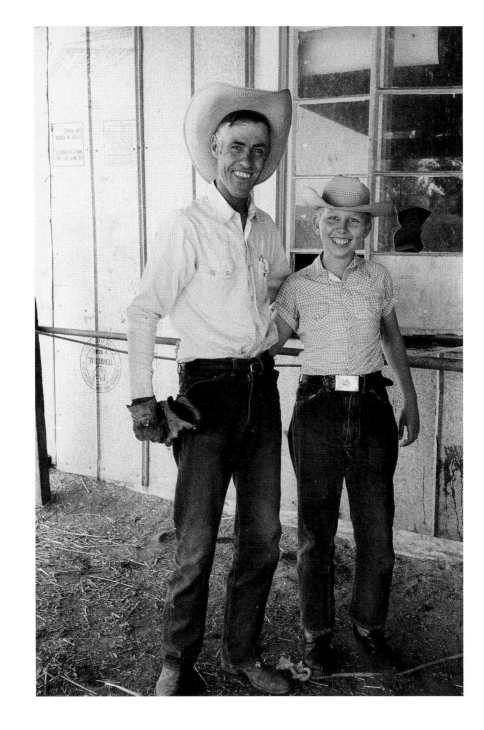

Father and son,
Montana, late
1950s.

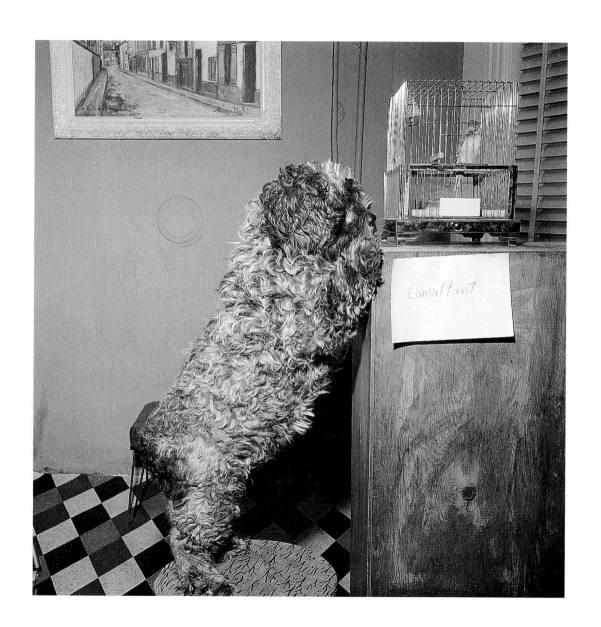

Back in New York, M.'s dog Pooh and the parakeet Sean, consulting, 1959.

M. FIRST VISITED CAPE COD, the towns of Truro and Provincetown especially, in the late fifties. Then, in 1960 she decided to come for the summer season and to open a photographers' gallery. Her ambition and her hope were great, as was her valor. At that time—almost fifty years ago now—photography was scarcely, or at best only by a few, regarded as an art. People bought paintings certainly but had not yet begun to purchase and cherish the photographs that now cost thousands of dollars, if one can find them.

She rallied her friends and made new friends among the photographers of those years. Edward Steichen said to her when she visited him to talk over her idea, "Are you crazy or rich?" to which she replied, "Well, I'm not rich." Nevertheless he joined her enterprise. Among the photographers whose work for the next few summers was shown at the VII Photographers Gallery (seven was the number of the original group, though it grew larger) were Berenice Abbott, W. Eugene Smith, Eugène Atget, Harry Callahan, Ken Heyman, Rollie McKenna, Barbara Morgan, Minor White, Lawrence Shustak, Aaon Siskind and Ansel Adams, as well as Steichen and, on occasion, M. herself. One day in the first summer a tall boy showed up when the gallery had just opened—dusty, with the proverbial sixties knapsack, and some photographs which she accepted; the dusty boy was a young William Clift.

ANSEL ADAMS

from PORTFOLIO I

1. Mt. McKinley, Alaska 1948

2. Saguero Cactus, Sunrise, Arizona 1946

3. Rapids Below Vernal Falls,
 Yosemite Valley 1948

4. Morman Temple, Manti, Utah 1948

5. Vine & Rock
 Island of Hawaii, T.H. 1948

6. Refugio Beach, California 1948

77. The white Church, Hornitor, Calif 1948

8. Roots, Foster Gardens, Honolulu, T.H.
 1948

9. Oak Tree , Snow Storm, Yosemite 1948

10. Trailside, Near Juneau, Alaska 1948

11. Alfred Stieglitz, An American Place,
 New York, 1938

12. Clouds Above Golden Canyon, Death
 Valley, California 1946

SINGLE Prints 35.00

Ansel Adams price list, 1964 show at VII Photographers Gallery.

Ansel Adams had a show in 1964. Could it be possible that the price he put on some of his prints was thirty-five dollars? Among the papers from the Gallery I have found such a price sheet.

The Gallery's final season was the summer of 1964. Many people had come to look and to admire, but not enough people bought photographs for the Gallery to be a viable way of life. To help the situation M. had added the sale of books, opening the East End Bookshop. Photographs were still there, on all available wall space, but the predominant business in that combination was literature. In the sixties whole families came to Provincetown, with their children and their children's summer reading lists, and M.'s selection provided their needs and, for us (we had begun to live together in the Gallery's final year), a more possible life. Previously M. had gone back to New York for the winter, but that long fall we kept lingering, feeling our roots settling into that magical and beautiful town, and so we stayed on. It was difficult—no tourists in winter, few buyers of books. But still, M. was taking and printing her own photographs, I was writing poems at the kitchen table, and we were young. And anyway so many painters and writers in Provincetown in those years were also doing their work, living in shacks, playing in the sun—or the snow. None of us had much money to count, or thought much about it.

I first met M. in the late fifties, at the home of the poet Edna St. Vincent Millay in upper New York State. I had gone there (the morning after I graduated from high school!) as a sort of pilgrim, I suppose. Steepletop, as it was called, was a place—an estate really—of many acres and much beauty and, of course, great interest. The poet, who had died in 1950, was buried in the woods beyond the houses—there were two, one a guest house and the other, the more grand, the poet's

home. This was 1953, and nothing had been changed by Norma Millay, the poet's sister, or her husband the actor and painter Charles Ellis, who then occupied the main house. I was seventeen; I was enthralled by everything, and more or less lived there for the next six or seven years, running around the 800 acres like a child, helping Norma, or at least being company to her. By and by, however, feeling in need of a life of my own—Norma's possessiveness was formidable—I had moved to New York City, to the Village. So much for scene setting.

When I came back to Steepletop one evening, with a friend, M., also with a friend, was sitting with Norma at the kitchen table. I took one look and fell, hook and tumble. M. took one look at me, and put on her dark glasses, along with an obvious dose of reserve. She denied this to her dying day, but it was true.

Isn't it wonderful the way the world holds both the deeply serious, and the unexpected mirthful? M. had been to Steepletop before—taking pictures. This was one of many return trips. Looking at the back of one of the prints she had brought for Norma to see I saw and announced, no doubt with considerable pleasure, that M. and I lived just across the street from each other in the Village. More reserve from M. However, we did little by little begin to see each other, and thus our own private story began.

I was living in England during M.'s first summers in Provincetown, and so was present during only the final season of the Gallery, and the beginning of the bookshop enterprise. I too fell in love with the town, that marvelous convergence of land and water; Mediterranean light; fishermen who made their living by hard and difficult work from frighteningly small boats; and, both residents and sometime visitors, the many artists and writers. Summer of course was the time of art shows, the

white buildings on Commercial Street were full of light and voices and the bright colors of paintings. The winters, we were to find out, were long and gray, with most of the windows boarded up and the restaurants closed. Those of us who remained roamed the streets, dependent on the A&P, the hardware store, the lumber company, the occasional party, and our own work. This is how it was then, when M. and I decided to stay.

Walking Home from Oak-Head

There is something
 about the snow-laden sky
 in winter
 in the late afternoon

that brings to the heart elation
 and the lovely meaninglessness
 of time.
 Whenever I get home—whenever—

somebody loves me there.
 Meanwhile
 I stand in the same dark peace
 as any pine tree,

or wander on slowly
 like the still unhurried wind,
 waiting,
 as for a gift,

for the snow to begin
 which it does
 at first casually,
 then, irrepressibly.

Wherever else I live—
　　in music, in words,
　　　　in the fires of the heart,
　　　　　　I abide just as deeply

in this nameless, indivisible place,
　　this world,
　　　　which is falling apart now,
　　　　　　which is white and wild,

which is faithful beyond all our expressions of faith,
　　our deepest prayers.
　　　　Don't worry, sooner or later I'll be home.
　　　　　　Red-cheeked from the roused wind,

I'll stand in the doorway
　　stamping my boots and slapping my hands,
　　　　my shoulders
　　　　　　covered with stars.

I N S O M E C O N S I D E R A T I O N O F M Y W R I T I N G S , a reviewer once surmised that I must have a private income of some substance, since all I ever seemed to do (in my poems) was wander around Provincetown's woods and its dunes and its long beaches. It was a silly surmise. Looking at the world was one of the important parts of my life, and so that is what I did. It was as simple as that. Poets, if they ever make a living from their writings, do not do so when they are first beginning to publish, and this was years ago. We did not, as I have said before, have much income. We had love and work and play instead.

But the Provincelands around our town held many secrets in their glistening beauty, and as we were young and bold and persistent in the ways of our chosen lives, we were also fairly fearless. Over the years I brought home many things—shells, feathers, once a hurt duck, twice a hurt gull, flowers always. The urgency of suppers simply added a new set of adventures to my ramblings. Along the shores and in the woods I began to recognize what was actually food. Actually everywhere, I learned, the earth is full of interest, artistry, and generosity.

Simple foods these were, that I found, but foods need no more than flavoring to become festive. The borders of the woods were thick with wild bay, as good as the kind that you buy. As I gathered their shining leaves, I could listen to the cardinal singing nearby, or watch the blue heron on its way from one pond to another lift and dip its enormous wings. A pleasant place to shop, this land, and in almost any season.

I remember one evening making rice—"rice with chicken and almonds" I said to M. as I set the bowls on the table, "only the almonds are imaginary, and the chicken ran away." Still, mixed with the rice and the bay were dark and fragrant slices of that king of mushrooms, the bolete, that I found every fall rising, at first crisp and later melting, in the pinewoods. In this season, for I put many away for the long winter, M. would come with me, and slowly and pleasantly we would fill our baskets. And we found also a plant called orach, with its tender stems and arrow-shaped leaves. Lover of ocean-edges, it sprawls so close to the waves that it comes to the table braced with its own sea salt.

And there were of course the cranberries. Feral cranberries, one might say, for they rose in bogs that were once tended and harvested, but no more. There I would hunch through the morning and have a good time too, and more than once glimpsed a deer watching me from behind the trees, or met the box turtle on his last days of rambling before his long winter sleep—or wrote a poem.

And all this is not even mentioning the sea. To the north and west flows and buckles the wild backshore, in the face of the Atlantic; to the south is the deep, gleaming harbor. M. and I were not much for catching fish, but should a gaffed blue be lost from a fishing boat and come to shore still lively, we were not against carrying it home.

And then, on the daily tidal flats so silently abide the tribes of the clams—the little-neck, the sea clam, the steamer. The clammers were a gang of sea-agriculturalists, reaping treasure from the depths of the sand. From any afternoon or morning of work, I would come home with four suppers, and more left over for us to give away. Or, in the colder months, I might gather a pailful of blue mussels, which many a person recognizes on the pretty menu but perhaps not so well on the even prettier rocks. One could gather a multitude in an hour, while the gulls with black-tipped wings circled above, crying out praises of their cold and wind-ruled lives. And I would gather, or I would watch the gulls—or write a poem.

In these years I had yet one more idea. I went to the old dump and gathered glass jars. I bought flour and yeast, sugar and wax. Then I went blackberry picking. Then I boiled and sweetened and strained the dark juice through cloth, filled the cleaned and sterilized jars, and sealed them with the wax. Then I baked bread—something I had never done before. Oh, what a week of sweet eating!

Things began to change after that. And we didn't disdain restaurants, the exquisite and dainty and plentiful foods. But neither did we ever forget the pleasures of our simplicity, our so-called hard years. When work was play, and play so thoroughly entered our work. We did not forget the bread, the jam, the bayberry, the gull, whose injuries to wings and legs were not reversible, who spent his last two months with us, splashing in the bathtub each morning, preening himself in the sun, asking to be turned around so he could watch the sunset, then turned again, so he could gaze with us into the evening fire.

Happily a friend in town gave M. the use of her darkroom. The process now has changed, but then it did indeed, except for the faintest red light bulb, take place in darkness. Sometimes I went with M. and watched as she developed or printed—a careful, timed business with vats and trays and potions. I watched not as one understanding the process—I never learned it—but as an observer seeing with excitement and delight how the long slips of film became a distant city, the desert, or a face revealing its personal story. A part of the pleasure no doubt was watching M.— her exactness, her patience, her certainty. Fortunate are all who have had such an experience, in whatever discipline—watching a painter paint, or hearing music as the notes lift and dip into something that will be everlasting—they are sacred moments. Especially if the person involved is someone you know intimately, but now all is cleared from the mind except the blessing, the heaven

of work. I never tired of watching. First the great, cumbersome enlarger, then the vats, then the first impressions appearing on the blank paper in its bath, the blacks deepening to M.'s approval. Maybe a touch from the bottle of ferrocyanide, maker of brightness. Then the dryer, then the decision if and how to crop, until there it was: the photograph. From that fragile film. From the camera. From the eye looking, and finding.

But there is this, too. Under that faint red light, M. all the while smoking, and sometimes checking temperatures by dipping a finger and tasting. Yes, it was a magical process and a magical time. Also, of course, it was beginning to ravage her lungs, a process that was fairly slow but, also, not reversible. When, in the seventies, she could no longer do the darkroom work and her vitality was beginning to diminish, she took fewer and fewer pictures, at least in the old, driven way. Yes, there were pictures still, developed commercially with one of the new digital cameras. But the role of maker, the seeker of faces first in the world and then coaxed onto the heavy Verigam paper, the smell of the dryer, the cropping, that was over. She gave the enlarger to a young friend just beginning to print. The enamel trays were useful in the kitchen. The negatives sat in their plastic slips; the prints, hundreds of them, went into their boxes.

(Text continues on page 69)

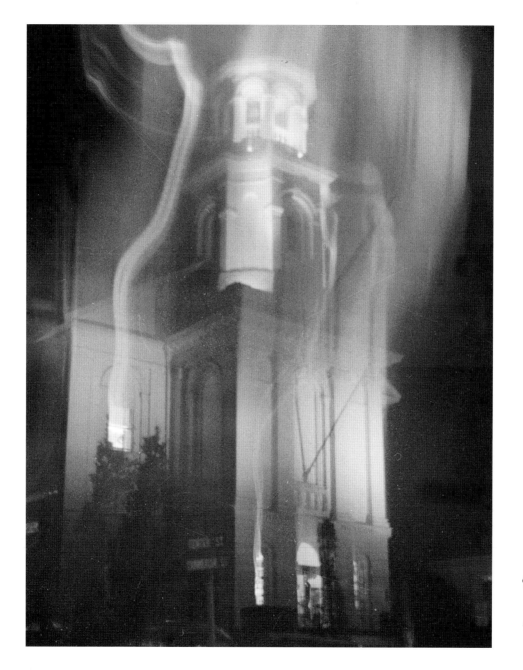

The Walter Chrysler
Art Museum in
Provincetown, in the
1960s, the evening
Andy Warhol came to
town. Time-lapse
photograph, plus lots
of strobe lights inside.
I didn't know who
Andy Warhol was. But
I found out.

The artist Al Hansen, Provincetown, 1960s. On a sunny day, a few of us together carried his construction into the museum.

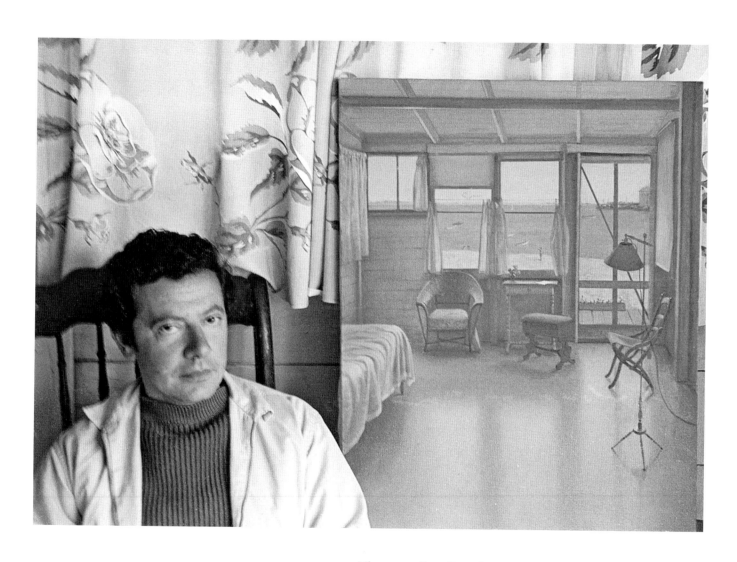

The artist Alvin Ross, Provincetown, 1960s. Behind his painting is the rest of his studio, exactly as he painted it.

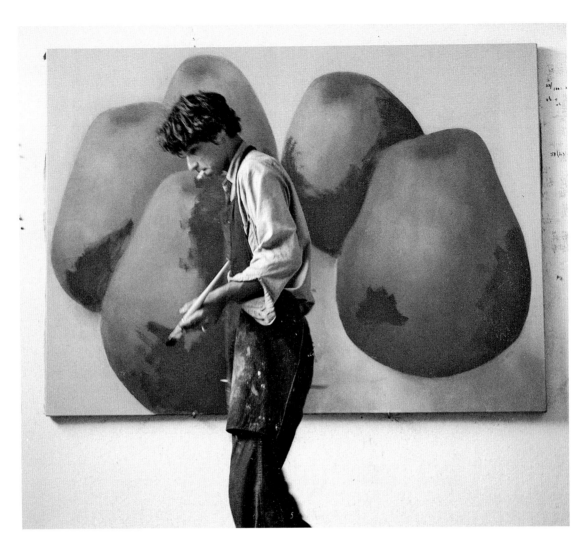

*Young artist
Peter Dechar;
he painted only
pears, but so
wonderfully,
1960s.*

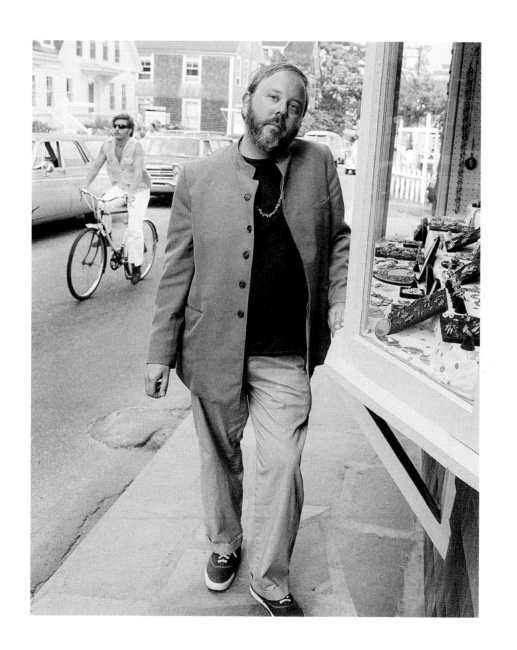

Henry Geldzahler, curator of 20th-century art at the Metropolitan Museum. When in Provincetown, he liked to come to M.'s East End Bookshop early in the morning and do the sweeping, 1960s.

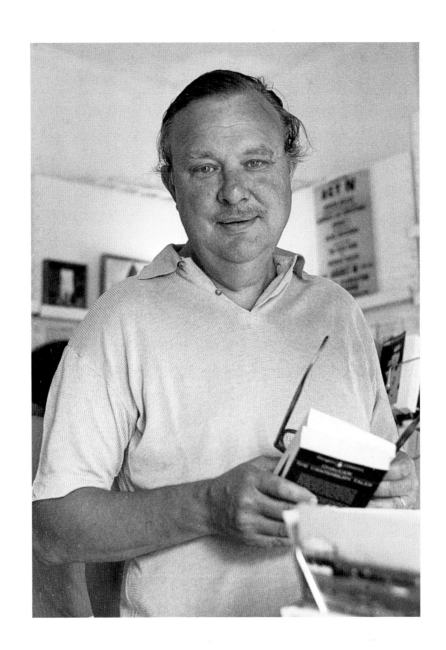

*Artist Robert
Motherwell in
M.'s bookstore,
1960s.*

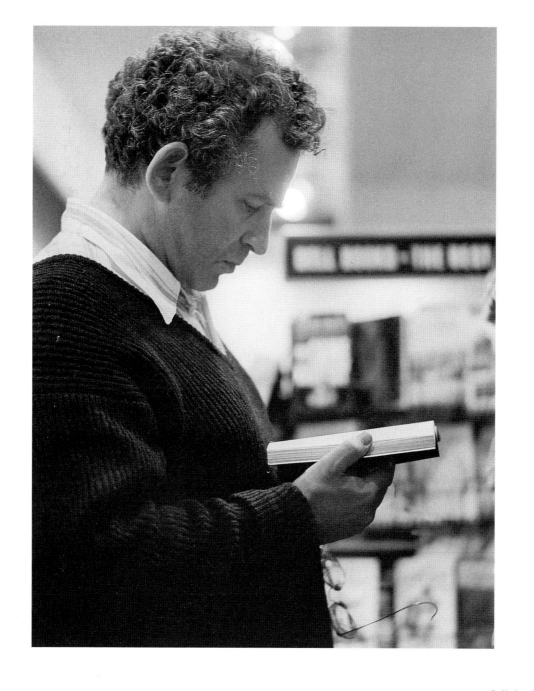

Another frequent visitor to M.'s bookstore, the writer Norman Mailer, 1960s.

*O*n a fall day in 1967, Walker Evans came into my East End Bookshop in Provincetown, Massachusetts, with the painter Fritz Bultman.

He was seriously surprised that I had both paperback and hardback copies of his book Message from the Interior *for sale.*

Evans appeared like a man who expected nothing, was slightly bewildered and found it hard to smile because he knew what was about to happen around the next corner, and it wasn't necessarily good.

He wrote in my hardback copy of Message from the Interior, *"Molly Malone Cook with pleasure and gratitude. Walker Evans 9/12/67." I asked him if I could take his picture, he looked puzzled and asked me why. I just took the picture.*

I had been interested and curious about Walker Evans since I'd first seen Let Us Now Praise Famous Men, *the book he and Agee did in the 1930s. Somehow I could not see Walker Evans in the middle of Alabama feeling as comfortable as James Agee did and from what I have read he wasn't.*

He seemed a very sad man, but oh what a fine eye he had.

Molly Malone Cook
Provincetown, Massachusetts
November 27, 1990

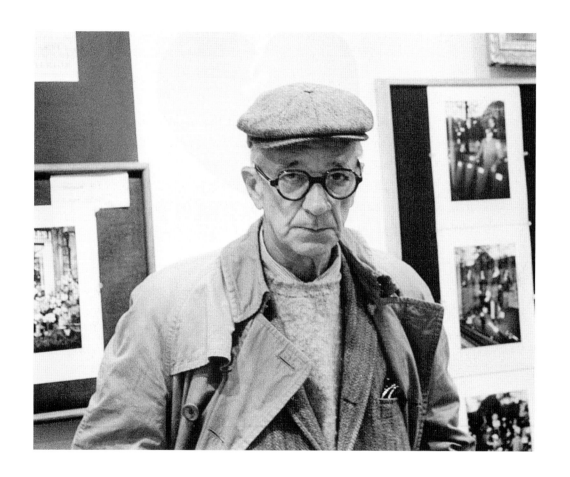

*Walker Evans
at the bookshop.*

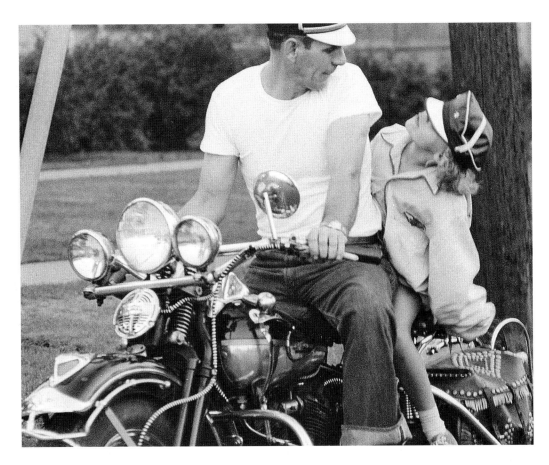

Big guy,
little girl,
big motorcycle, 1960s.

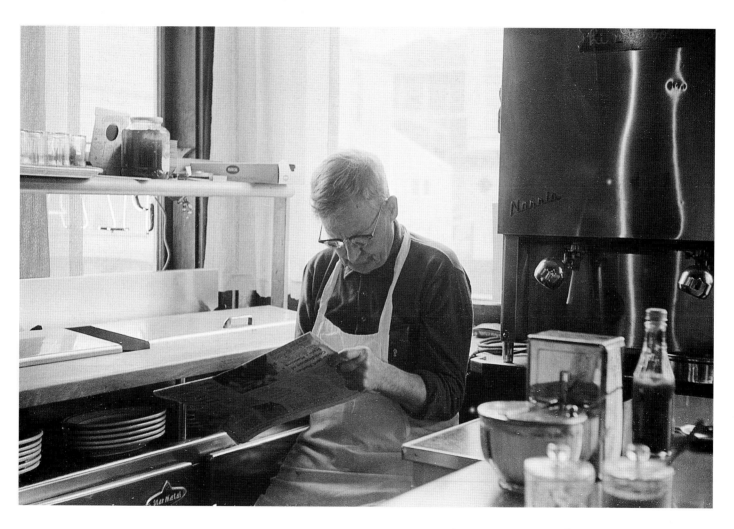

*Mike Janapolis, owner of the Mayflower Café, which
often kept us alive, 1960s.*

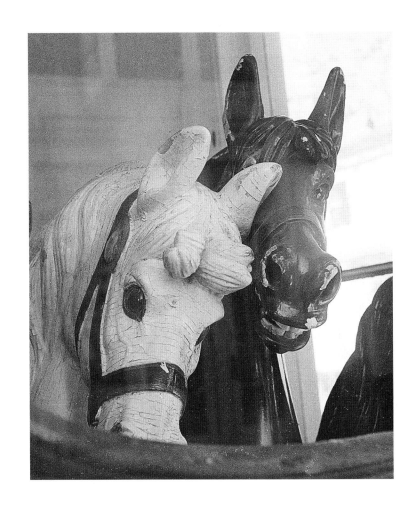

*Old merry-go-round
horses, two of many
stuffed into a small
empty building,
waiting for repair,
1960s.*

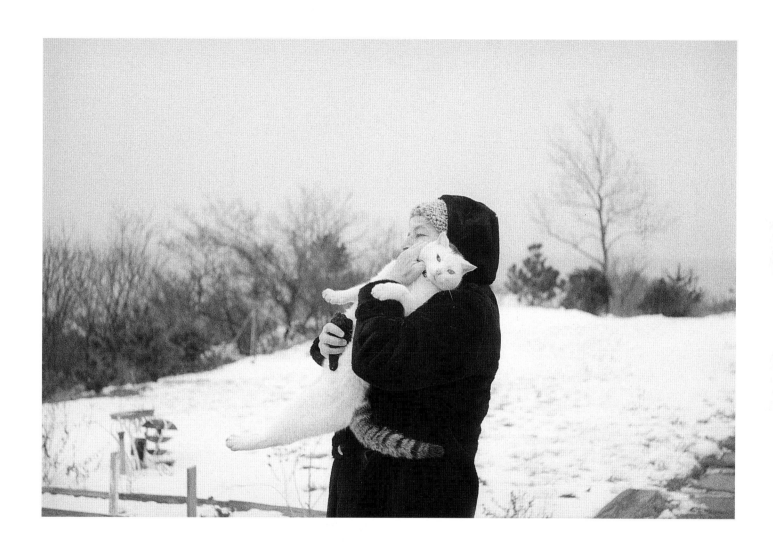

*Ray Wells
and Toby,
1960s.*

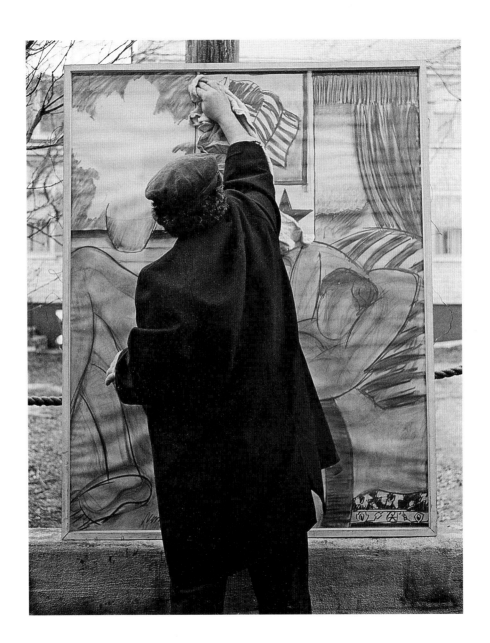

Reggie Cabral,
owner of the
Atlantic House,
sprucing up a
Tom Wesselmann
painting, 1960s.

Librarian
Marian
Haymaker with
her daughter,
Anne Josephine,
1966.

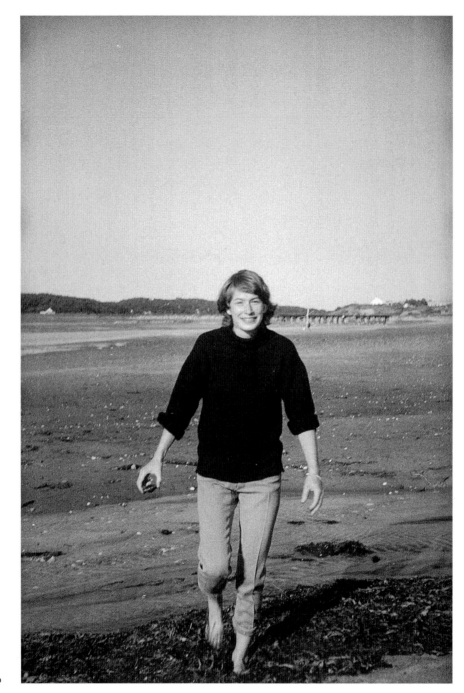

My first clam,
1964.

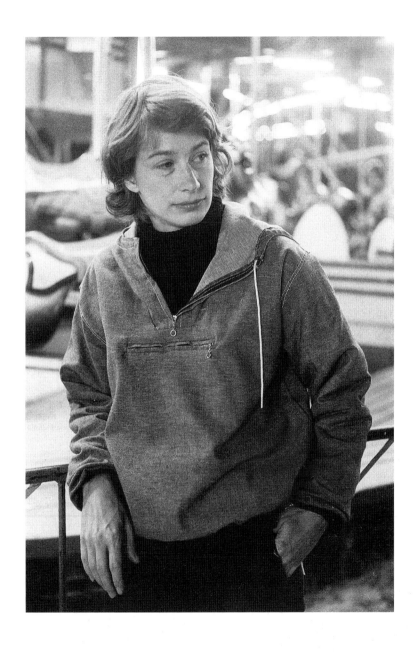

Summer,
1964.

Helping the
traveler,
1965.

Those Days

When I think of her I think of the long summer days
 she lay in the sun, how she loved the sun, how we
 spread our blanket, and friends came, and

the dogs played, and then I would get restless and
 get up and go off to the woods
 and the fields, and the afternoon would

soften gradually and finally I would come
 home, through the long shadows, and into the house
 where she would be

my glorious welcoming, tan and hungry and ready to tell
 the hurtless gossips of the day and how I
 listened leisurely while I put

around the room flowers in jars of water—
 daisies, butter-and-eggs, and everlasting—
 until like our lives they trembled and shimmered
 everywhere.

I N 1 9 6 9 M. S U F F E R E D A N I L L N E S S, lung-related, significant enough for us to close the bookstore. And thus fairly finished was the forwarding of her own work in photography, as well as the forwarding of the work of other photographers.

Not that our active life ended, not at all. M. would work for several years with a well-known writer, assisting in areas both professional and personal. I would, for some years, type his manuscripts. My job was hard; hers was impossible. M. also began, in 1976, a literary agency, finding publishers for some excellent books, and certainly she forwarded the publishing part of my life. But that was the least of it.

It has frequently been remarked, about my own writings, that I emphasize the notion of attention. This began simply enough: to see that the way the flicker flies is greatly different from the way the swallow plays in the golden air of summer. It was my pleasure to notice such things, it was a good first step. But later, watching M. when she was taking photographs, and watching her in the darkroom, and no less watching the intensity and openness with which she dealt with friends, and strangers too, taught me what real attention is about. Attention without feeling, I began to learn, is only a report. An openness—an empathy—was necessary if the attention was to matter. Such openness and empathy M. had in abundance, and gave away freely. All the years I knew her she had this gift, which is also sometimes a burden, with our life friends, with me, and with the

faces and even the objects that found their way into her pictures. I was in my late twenties and early thirties, and well filled with a sense of my own thoughts, my own presence. I was eager to address the world of words—to address the world with words. Then M. instilled in me this deeper level of looking and working, of seeing through the heavenly visibles to the heavenly invisibles. I think of this always when I look at her photographs, the images of vitality, hopefulness, endurance, kindness, vulnerability. Her world certainly wasn't daisies or birds or trees, as mine was; we each had our separate natures; yet our ideas, our influence upon each other, became a rich and abiding confluence.

Somewhere in my writings I have described how M., unfailingly, whenever I came home from a walk in the woods or the fields, would say, "How was it?" and how dear this question was to me. Reading in her journals this last year and a half I came upon the following entry:

> Mary has just returned with yellow flowers
> and a wet Luke who has been swimming in the
> ponds. I always ask her for news. What does
> that mean, what news am I looking for? Good,
> I imagine. What I mean is news of humans.
> Mary comes home with fox news, bird news,
> and her loving friends the geese Merlin and
> Dreamer, who are going to become parents
> under Mary's eyes once again. How many years
> has she been watching them? They come
> running to her. That's Mary's news.

I don't think I was wrong to be in the world I was in, it was my salvation from my own darkness. Nor have I ever abandoned it—those earthly signs that so surely lead toward epiphanies. And yet, and yet, she wanted me to enter more fully into the human world also, and to embrace it, as I believe I have. And what a gift to read about her wish for it, who never expressed impatience with my reports of the natural world, the blue and green happiness I found there. Our love was so tight.

In all our time together we were rarely separated. Three or four times I went away to teach, but usually M. would come with me, and we simply made our home, temporarily, somewhere else. And, while I always loved the stillness I found in the fields and the woods, our house was a different thing, and I loved that too. We were talkers—about our work, our pasts, our friends, our ideas ordinary and far-fetched. We would often wake before there was light in the sky and make coffee and let our minds rattle our tongues. We would end in exhaustion and elation. Not many nights or early mornings later, we would do the same. It was a forty-year conversation.

The end of life has its own nature, also worth our attention. I don't say this without reckoning in the sorrow, the worry, the many diminishments. But surely it is then that a person's character shines or glooms. M.'s strength waned, over and over she met with some obstacle that might be called the-body-can't-do-it-anymore. She was cheerful during repetitive hospital stays; she was sometimes hilarious with visitors, wonderfully off-hand. "Oh," she would say, flipping her

hand as if scooting a fly, "it's just a little tumor." Her boat was still in the harbor and once in a while she would struggle aboard and have a good time, though a brief good time. To get out of the boat she contrived the only manner possible, she flung herself overboard into the shallow water, laughing, until we all laughed with her. Finally, she gave the boat away. Good lungs we need, and hers were failing. That is the way it goes sometimes, slowly. The vitality goes somewhere else into this world. And then the life.

From M.'s Journals

M.'s handwriting, often, might just as well have been the Rosetta stone. But around 1986 she got her first computer and for some years afterward her journals are, may I say, accessible. I include a few entries that she may herself declare her mind and spirit.

Most of the excerpts were written in Provincetown, in the eighties; the final one was written in Virginia in 1991.

Mary excited has run down the street looking for
a pair of swans. I wish her good luck, she has
been thinking about swans for a couple of days
and lo and behold, as they say, someone told
her this morning there were indeed two swans in
the harbor. Eureka I'd say. May I have the luck that
she has on the wishing pole. I'll not name my
wish now. As mentioned perhaps she found Linda out
their way and is showing her the swans, indeed
like two mad women they are chasing up the street,
shouting "out of the way, out of the way, we
search for swans."

(I was giving a reading at a college in Rhode Island.)

We drove to Providence on Thursday and met the
dragon draped in black, buried in black and
hanging with bent gold-tipped jewels and a foul
mouth. We lived through it and hung on. "I've
been in charge of poetry readings here since
1978 and no one has ever refused to be taped."
"Then you must have a lot of tapes," said I.

*(We were for a time living in a house in the
East End of Provincetown, on the water. It was
owned for many years by the artist Robert Ball
and his wife, Margery, and was lived in at times
by Eugene O'Neill.)*

What I see here and think about will soon be
gone, witness Susan Glaspell's words about what
was and Mary Heaton Vorse's about what was. The
Balls and all they have left here. Did he live
out in the studio? Her father upstairs? Her

mother across the street in a rented room?
Didn't O'Neill cross the street to fall into the
sea and swim round and round and look back at
this house, climb those stairs out there? How I
resent and search for inanimate objects that
stay on after everyone is gone. An old notebook
will turn up in a trunk stored in some garage.
Out comes a muffled half story, one-sided. We
tell the story from our safe side. Our blind
side. And history packs it up, marches with it.

(Carolyn Chute, author of The Beans of Egypt,
Maine, came occasionally to Provincetown, and we
took the opportunity to become friends. It
wasn't always easy to remember her phone
number, which was listed under the name of
her pet goose.)

I called Channel Five to get a tape of Carolyn
Chute, we will send a blank tape and hope for
the best. We are going to try and call Carolyn

now. I am bust this morning. Then we will go
downtown and get a PIN number whatever that is
from the bank and throw our money down a tube,
we have become very foolish in our old age.

Mary and I had a funny on the deck. I shall try
to get it down. I went to the P.O. and when we were
sitting on the deck in that moment of sun I said:
"I was fooling around in the P.O. with Cohen."
"Roy Cohen?"
"No, for Christ's sake, he's dead."
"What difference does that make?" she asks. And
we die laughing.

*(NJ, for Norma Jean, was our cat, whose mother had
died recently. Jasper was one of our dogs.)*

Outside the door NJ screaming once again,
this time from the outside, seaward, and it's

windy today. I opened the door and let the
voice in the house once again. She climbs now
up to Jasper for comfort. Comfort. Someone
to hug is what she is screaming for. Nothing
different from any other living soul.

3:45am, 14th of September '87 and look who's
here! It's me.

We all have loads to lift and wheelbarrows to tilt.

Friday night Arthur came down to the shack in the
late afternoon and then we went home to
dinner with him. It was nice. Elizabeth had her hands
full with her fellow musician and his mother,
that kid never had a chance, women are
terrifying aren't they. Everything asked her

was "too complicated to answer." When all was
clear Elizabeth made dinner like a trooper and Arthur
helped by biting off the heads and tips of the
carrots and spitting the pieces out into a
bowl. It was wonderful. Ezekiel has grown a lot and
is very handsome. He spent the entire time
running his hand flat over the top of his head.
It was hypnotizing.

Have taken another walk, have been outside
after seeing a sweet spider crawling around
from inside the basement window, went
outside to look for her/him but didn't find
him/her and didn't try too hard, I don't like
spiders, what in hell was I doing? Loving
everything? Was that it?

Last night I turned on the TV and there she was.
It was wild. Her voice. I couldn't replay
it. She spoke only a few words. It was mind-

boggling. I wonder if I shall ever be able
to come back to listen and watch her again.
Strange I should have fixed the VCR just a
moment before she came on.
Well I never thought I would see her again—
knew I would never hear her voice again in
this world. Oh I did always think I would
see her again and hear her voice again, but
not in this world.

People travel to keep from crying in place.

(Bear was another one of our dogs.)

Deep in the sunshine again yesterday, at the
seaside. Bear gone fishing, running down the
beach, a long way to us carrying something big
in his mouth. It proved to be a fish and we
brought it home and ate it. Bear caught our

dinner, when Mary was wondering what we were
going to eat. Well we had flounder for dinner
and Bear caught it.

*(Mr. Dew, renamed Benjamin, lived with us for
thirteen years.)*

There is a beagle outside, Mary has fed him
and named him Mr. Dew after the man who
first lived in this house. Dear God, what
eyes.

6am and Mr. Dew slept the night on the porch
of the first Mr. Dew's house. The beagle,
beautiful eyes, who is lost. I suppose
while hunting, and we're torn, I'm torn,
he cannot come in for I couldn't breathe, yet
there he is having slept the night away on
the front porch. Mary went out to feed him
first thing and now he waits for her with
shining eyes. He must belong to a hunter,

maybe he has been in a pen with others, maybe
he is somebody's dear pet. Suffice, though,
he's here with us now and how can we turn
away from those eyes?

The Whistler

All of a sudden she began to whistle. By all of a sudden
I mean that for more than thirty years she had not
whistled. It was thrilling. At first I wondered, who was
in the house, what stranger? I was upstairs reading, and
she was downstairs. As from the throat of a wild and
cheerful bird, not caught but visiting, the sounds war-
bled and slid and doubled back and larked and soared.

Finally I said, Is that you? Is that you whistling? Yes, she
said. I used to whistle, a long time ago. Now I see I can
still whistle. And cadence after cadence she strolled
through the house, whistling.

I know her so well, I think. I thought. Elbow and an-
kle. Mood and desire. Anguish and frolic. Anger too.
And the devotions. And for all that, do we even begin
to know each other? Who is this I've been living with
for thirty years?

This clear, dark, lovely whistler?

AFTER NOTE

How often now I just sit, with my
elbows on the desk and my hands
holding my face bold and upright,
and stare into the past.

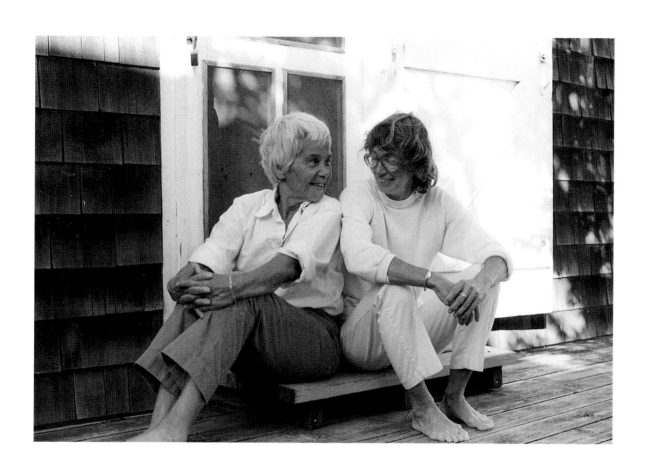

ACKNOWLEDGMENTS

The creation of this book could not have been accomplished without the help of many people, whom I wish to thank.

My deep and enduring thanks to Helene Atwan, the director of Beacon Press. I have had no better medicine these last years than her enthusiasm and her friendship. Many others at Beacon Press have also given careful and loving effort to the project, especially Tom Hallock and P. J. Tierney.

Also I wish to thank: Fred M. Cook, Anne Taylor, Jill Geier, Daniel Franklin, Bill and Amalie Reichblum, Noah and Clarissa Reichblum, Frank X. Gaspar, Jane Jensen, Sique and Andy Spence.

The Right Reverend M. Thomas Shaw, SSJE, Stephen Johnson, Jeffrey Adams, Rosemary Bryant, Magarita Quiroz, Pat de Groot, Jody Melander, Graham Giese, Paulus Berensohn, Brian O'Malley, Wilsa Ryder, Djordje Sôć, and John Waters.

They are all my family now.

M. O.